THIS BOOKS BELONGS TO:

...

...

...

Learn how to draw an Alien!

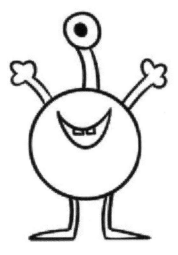

Draw your Alien here.

Learn how to draw a Martian!

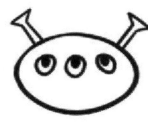

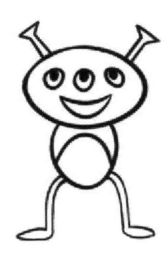

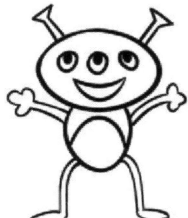

Draw your Martian here.

Learn how to draw the Apollo lander!

Draw your Apollo lander here.

Learn how to draw the Apollo mothership!

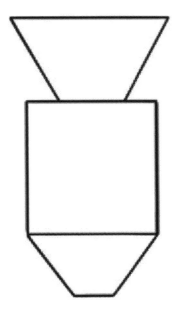

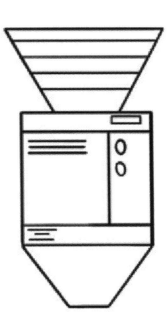

Draw your Apollo mothership here.

Learn how to draw a Astronaut!

Draw your Astronaut here.

Learn how to draw a black hole!

Draw your black hole here.

Learn how to draw a cresent moon!

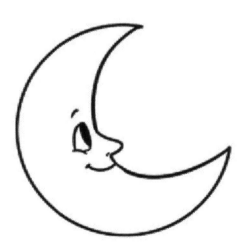

Draw your cresent moon here.

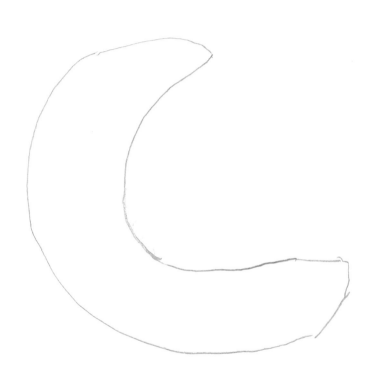

Learn how to draw the Earth!

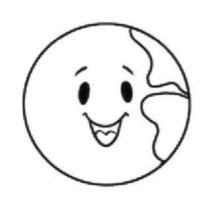
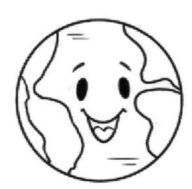

Draw your Earth here.

Learn how to draw a galaxy!

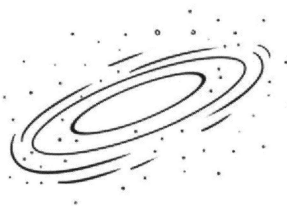

Draw your galaxy here.

Learn how to draw Jupiter!

Draw your Jupiter here.

Learn how to draw the Mars rover!

Draw your Mars rover here.

Learn how to draw Mars!

Draw your Mars here.

Learn how to draw Mercury!

Draw your Mercury here.

Learn how to draw a meteor!

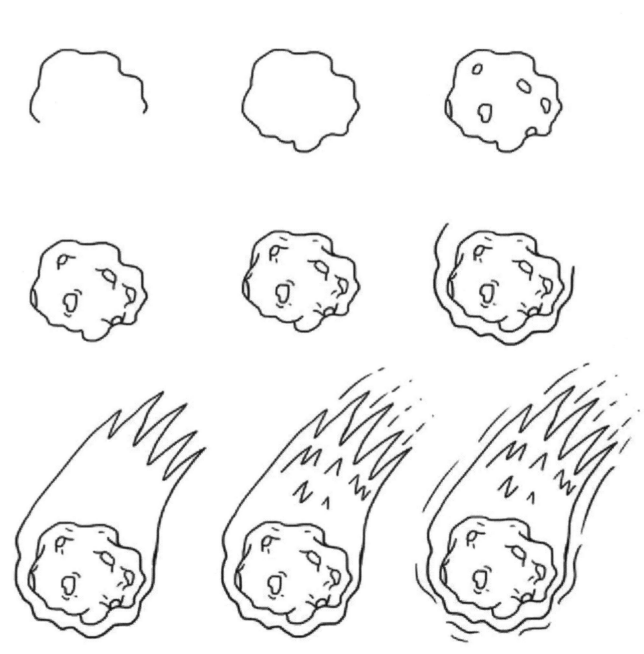

Draw your meteor here.

Learn how to draw the Moon!

Draw your Moon here.

Learn how to draw Neptune!

Draw your Neptune here.

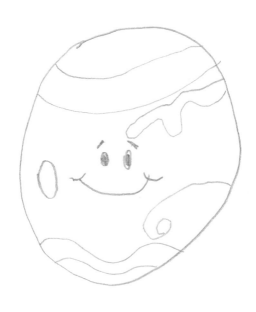

Learn how to draw an observatory!

Draw your observatory here.

Learn how to draw Pluto!

Draw your Pluto here.

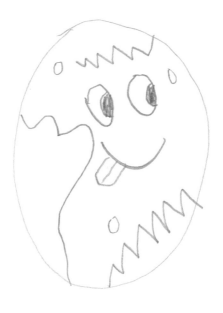

Learn how to draw a satellite!

Draw your satellite here.

Learn how to draw Saturn!

Draw your Saturn here.

Draw your shooting star here.

Learn how to draw a space ship!

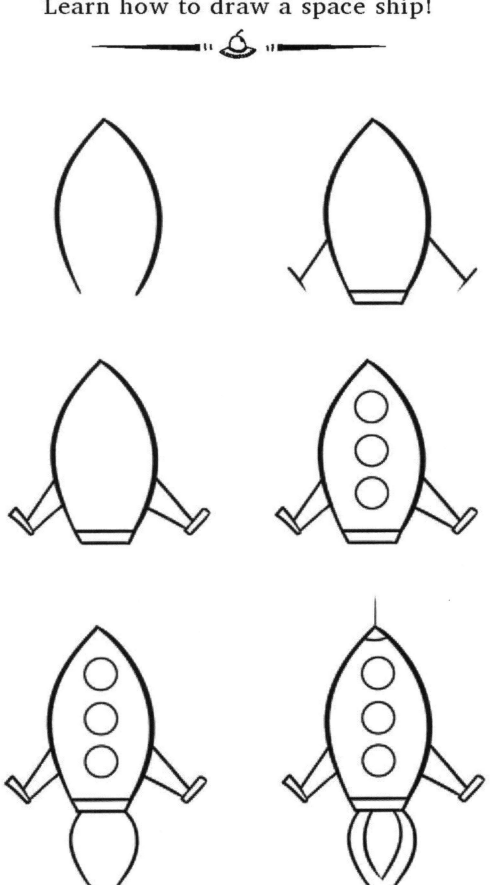

Draw your space ship here.

Learn how to draw a star!

Draw your star here.

Learn how to draw the Sun!

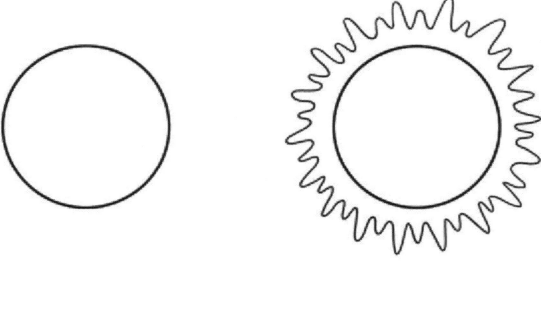

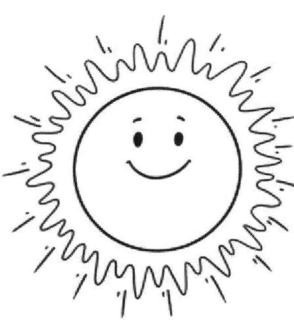

Draw your Sun here.

Learn how to draw a Telescope!

Draw your Telescope here.

Learn how to draw a UFO!

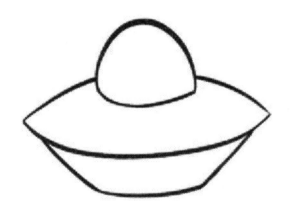

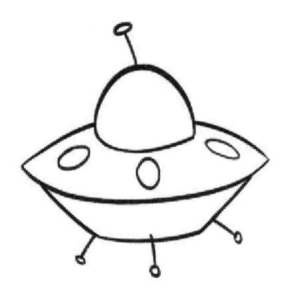

Draw your UFO here.

^

Learn how to draw Uranus!

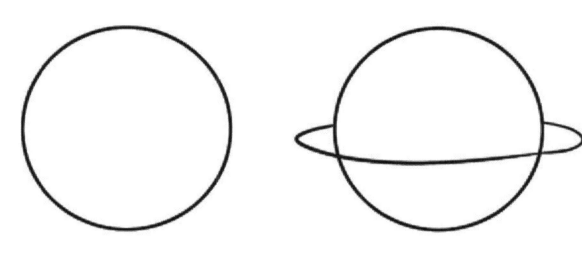

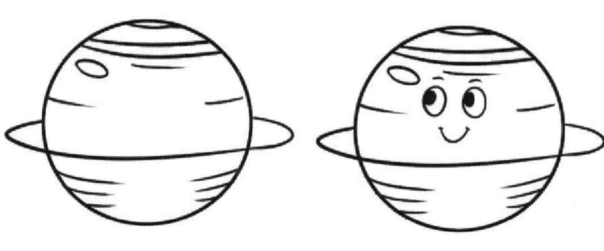

Draw your Uranus here.

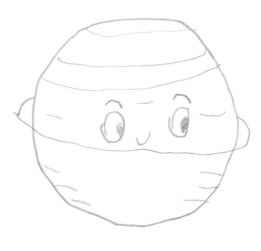

Learn how to draw Venus!

Draw your Venus here.

Manufactured by Amazon.ca
Bolton, ON